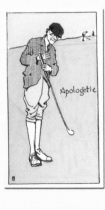
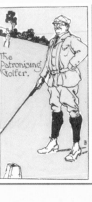
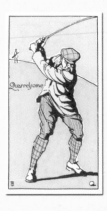

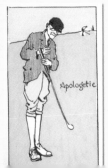
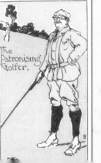
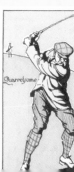

HAMMOND
(GLOUCESTERSHIRE)

P. HOLMES. YORKSHIRE

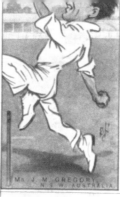

C. HALLOWS
(LANCASHIRE)

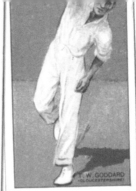

Mr. J. M. GREGORY
N.S.W. AUSTRALIA

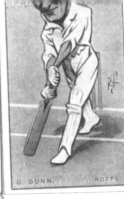

T. W. GODDARD
(GLOUCESTERSHIRE)

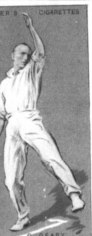

G. GUNN. NOTTS

PLAYER'S CIGARETTES

G. GEARY
(LEICESTERSHIRE)

PLAYER'S CIGARETTES

C. W. L. PARKER
GLOUCESTERSHIRE

PLAYER'S CIGARETTES

A. H. H. GILLIGAN (SUSSEX)

PLAYER'S CIGARETTES

W. R. HAMMOND
(GLOUCESTERSHIRE)

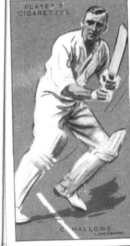

PLAYER'S CIGARETTES

P. HOLMES. YORKSHIRE

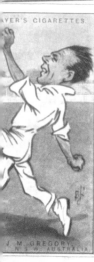

PLAYER'S CIGARETTES

C. HALLOWS
(LANCASHIRE)

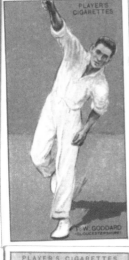

PLAYER'S CIGARETTES

J. M. GREGORY
N.S.W. AUSTRALIA

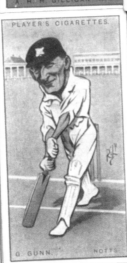

PLAYER'S CIGARETTES

T. W. GODDARD
(GLOUCESTERSHIRE)

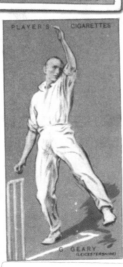

PLAYER'S CIGARETTES

G. GUNN. NOTTS

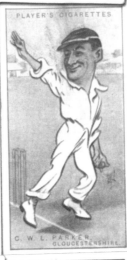

PLAYER'S CIGARETTES

G. GEARY
(LEICESTERSHIRE)

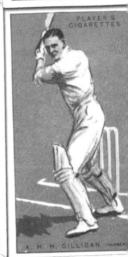

PLAYER'S CIGARETTES

C. W. L. PARKER
GLOUCESTERSHIRE

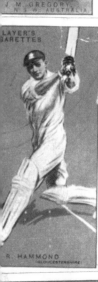

PLAYER'S CIGARETTES

A. H. H. GILLIGAN (SUSSEX)

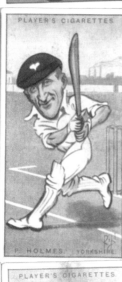

PLAYER'S CIGARETTES

R. HAMMOND
(GLOUCESTERSHIRE)

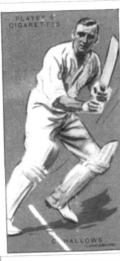

PLAYER'S CIGARETTES

P. HOLMES. YORKSHIRE

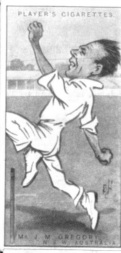

PLAYER'S CIGARETTES

C. HALLOWS
(LANCASHIRE)

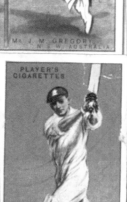

PLAYER'S CIGARETTES

Mr. J. M. GREGORY
N.S.W. AUSTRALIA

PLAYER'S CIGARETTES

T. W. GODDARD
(GLOUCESTERSHIRE)

PLAYER'S CIGARETTES

G. GUNN. NOTTS

PLAYER'S CIGARETTES

PLAYER'S CIGARETTES

PLAYER'S CIGARETTES

PLAYER'S CIGARETTES

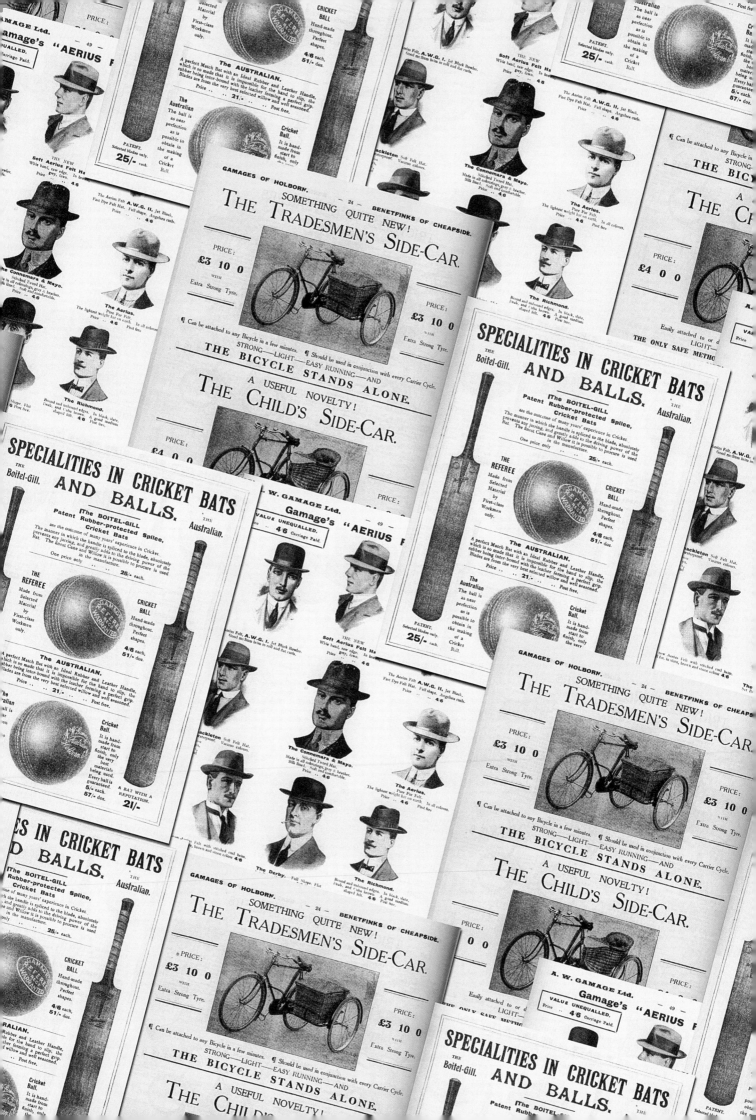

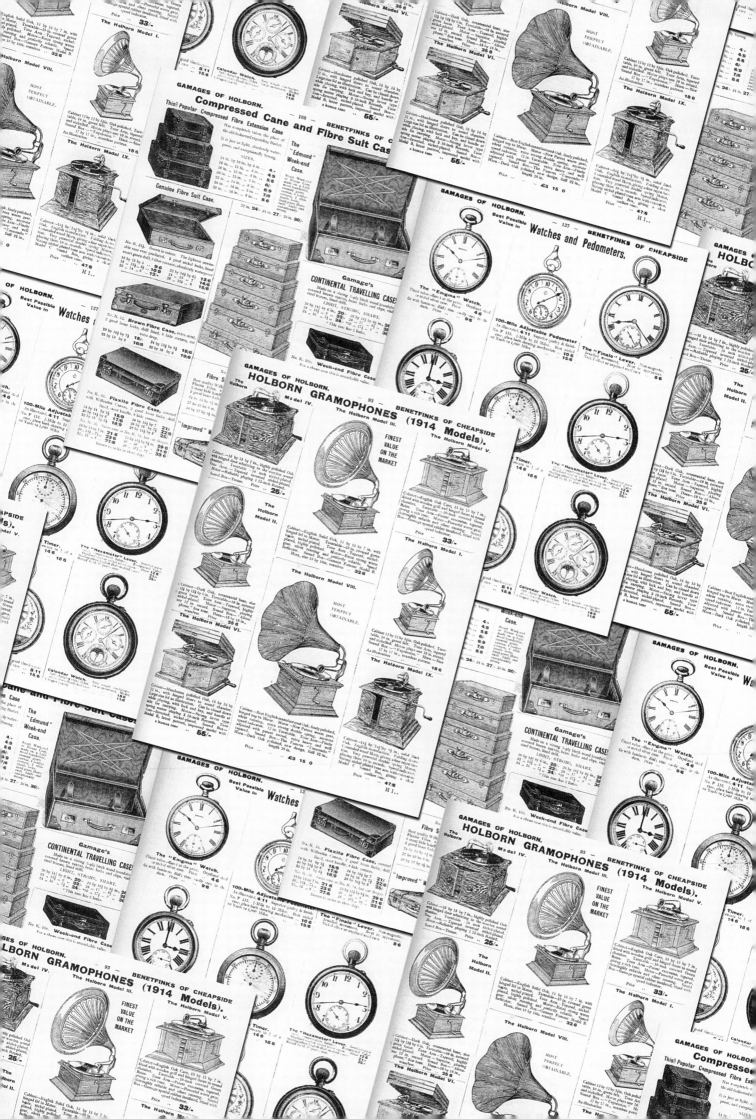

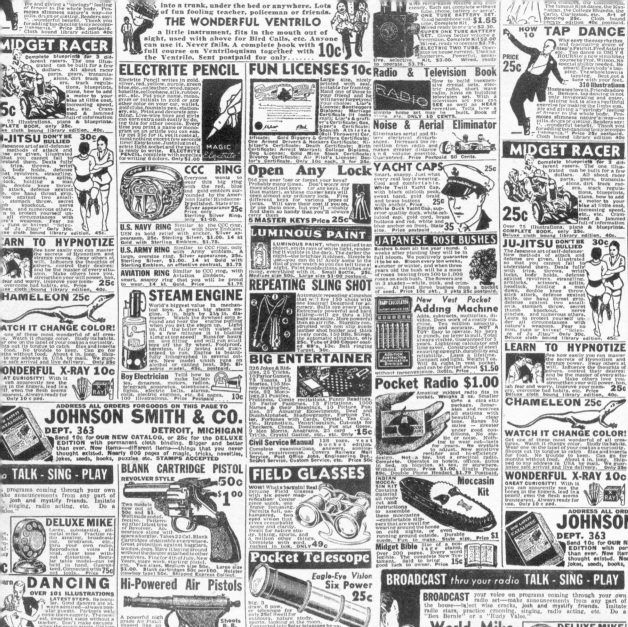

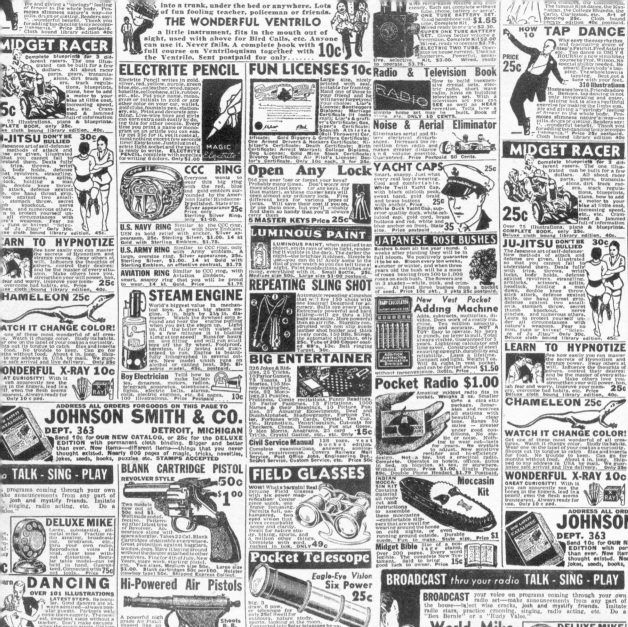

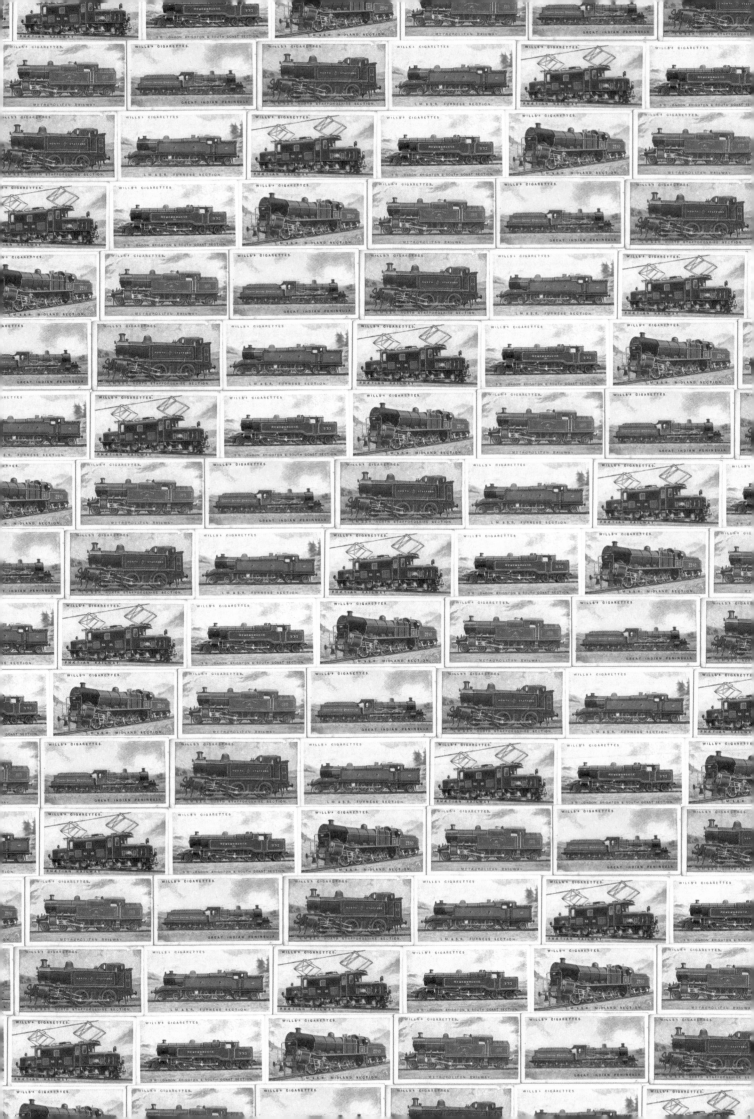

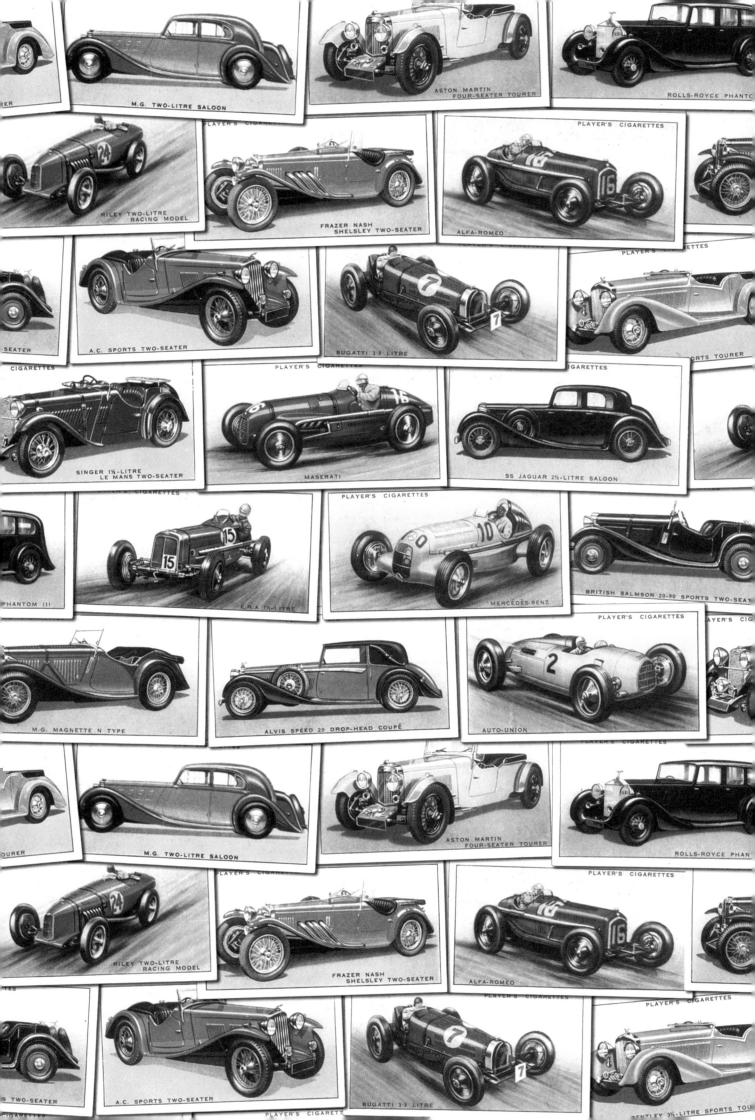

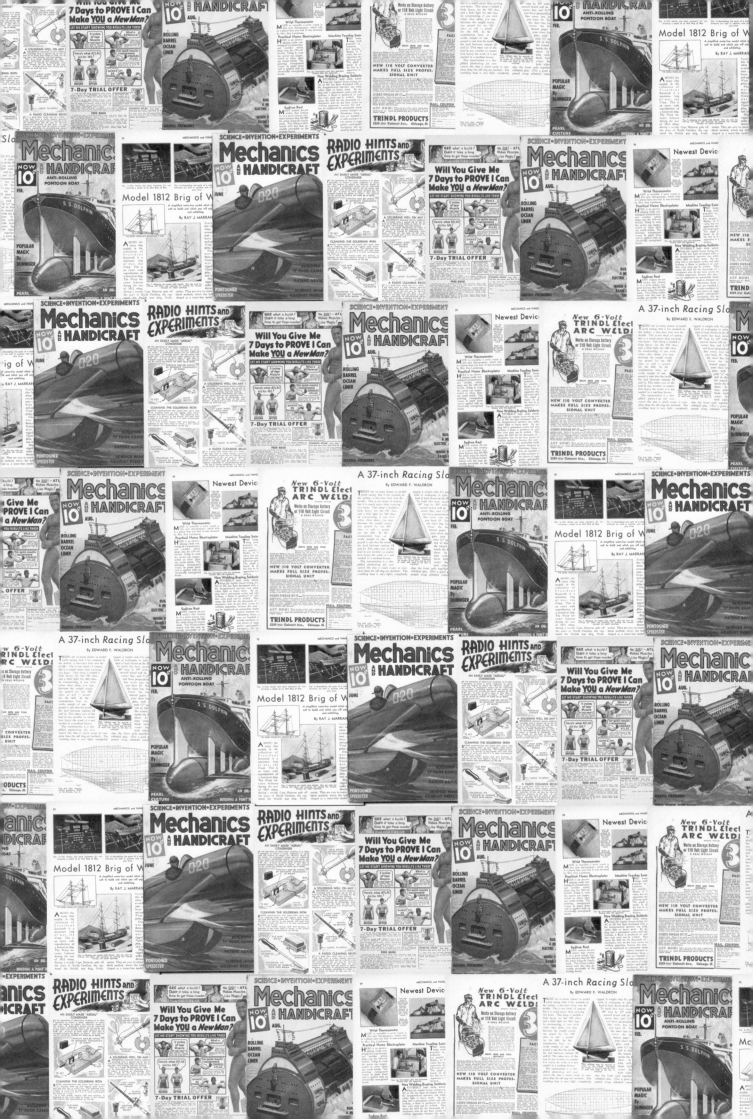